SHREWSBURY

HISTORY TOUR

Cop.

First published 2019

Amberley Publishing
The Hill, Stroud,
Gloucestershire, GL5 4EP
www.amberley-books.com

Copyright © Dorothy Nicolle, 2019
Map contains Ordnance Survey data
© Crown copyright and database
right [2019]

The right of Dorothy Nicolle to be
identified as the Author of this work
has been asserted in accordance with
the Copyrights, Designs and Patents
Act 1988.

ISBN 978 1 4456 9328 6 (print)
ISBN 978 1 4456 9329 3 (ebook)

British Library Cataloguing in
Publication Data.
A catalogue record for this book is
available from the British Library.

Origination by Amberley Publishing.
Printed in Great Britain.

ABOUT THE AUTHOR

Dorothy Nicolle came to live in Shropshire some thirty years ago and fell in love with the county. She then decided that the best job in the world would be to share her discoveries with anyone else who might be interested and so, in 1993, she qualified as a Blue Badge tourist guide. In the years since she has lectured on various local history themes and has also written a number of books on both local and general history. For information about her tours, talks and books please visit her website at www.nicolle.me.uk.

INTRODUCTION

On reaching this part of Britannia the Anglo-Saxon invading forces were looking to settle and it only needs one glance at the aerial photograph below to understand why they chose this spot: it's a wonderful hilltop site surrounded by a river that provides not just defence but also excellent communications with much of southern England. Even the town's name, Shrewsbury, reminds us of this – any early settlement with a 'bury' suffix indicates one that was important enough to be well defended. As for the 'Shrew' part of the name? Again, we don't know for sure but I prefer the suggestion that it was a personal name – this, then, was Scrobbe's fortification.

By the time of the Norman invasion the town was thriving. The River Severn continued to serve its purpose for the next few hundred years as Shrewsbury grew to become one of the dozen most important towns in England. It was an important market town and meeting place serving people from all over central England and Wales. However, with the onset of the Industrial Revolution, Shrewsbury's relative importance declined. In many ways, however, this has given the town a new importance. The old buildings and stories that survive give Shrewsbury a charm that cannot be denied so that people still visit or, if they're lucky, come to live here.

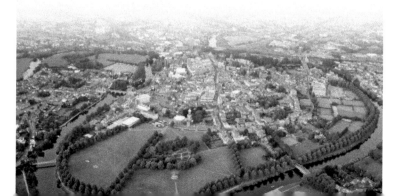

KEY

1. Shrewsbury Railway Station
2. Entrance to Shrewsbury Castle
3. Shrewsbury Castle
4. Laura's Tower
5. View to Railway Signal Box
6. Castle Gates House
7. Shrewsbury Library
8. Charles Darwin
9. Council House Entrance
10. Traitor's Gate/St Mary Waterlane
11. The Parade
12. St Mary's Church
13. St Mary's Church – the Fallen Roof
14. St Mary's Church – the Stained Glass
15. The Drapers Hall
16. Pride Hill
17. Butcher Row
18. St Alkmund's Church
19. Newport House
20. Wyle Cop
21. Henry Tudor House
22. Lion Hotel
23. St Julian's Church
24. Bear Steps
25. Fish Street
26. Grope Lane
27. Margaret Thatcher and Michael Heseltine
28. Ireland's Mansion
29. Lloyds Bank
30. The Square
31. Robert Clive
32. The Old Market Hall
33. Gullet Passage
34. Shrewsbury Museum and Art Gallery
35. The Golden Cross
36. Old St Chad's Church
37. Town Walls Tower
38. Kingsland Mansion
39. New St Chad's Church
40. Scrooge's Grave
41. The War Memorial
42. The Quarry
43. Percy Thrower and the Dingle
44. The River Severn
45. Shrewsbury School
46. The Riverside Walk
47. Kingsland Bridge
48. English Bridge
49. Wyle Cop
50. Shrewsbury Abbey
51. The Column

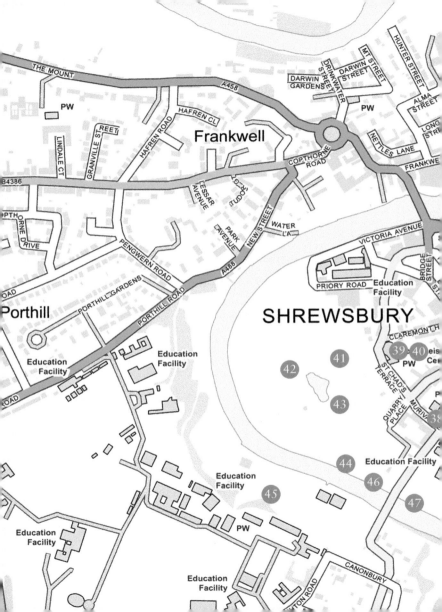

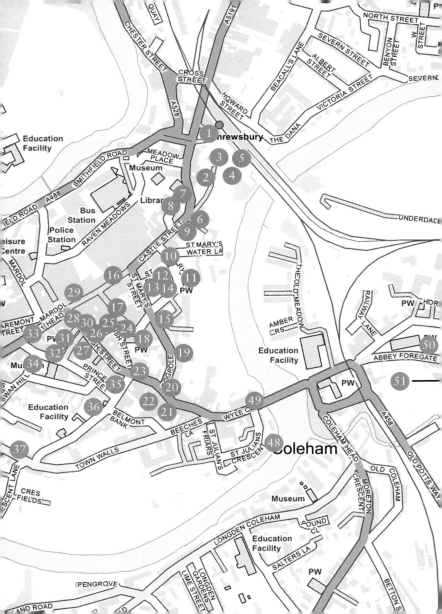

1. SHREWSBURY RAILWAY STATION

For the purposes of this tour I'm going to imagine you've just arrived in Shrewsbury on the train. As you leave the station turn around and look at the building. It's remarkably ornate. Built in 1848/49, it was originally a two-storey building. However when, fifty years later, it was decided to add an extension, the additional floor was inserted under the entire building – the original entrance was just above the present one. Victorian engineering at its finest.

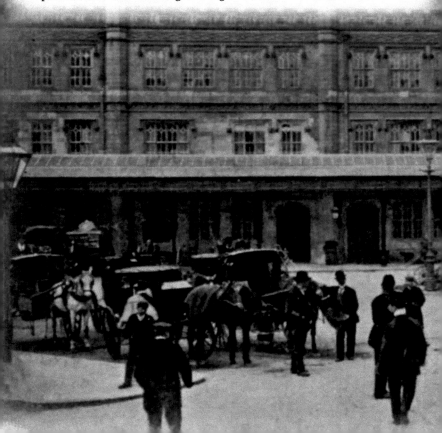

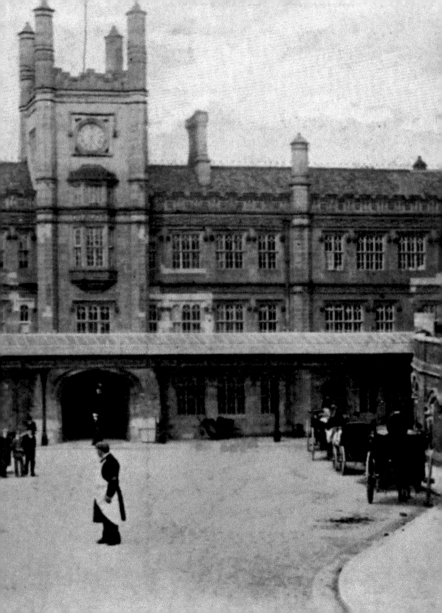

2. ENTRANCE TO SHREWSBURY CASTLE

After the Norman Conquest this region was placed under the control of one of William's men, Roger de Montgomery, who built a wooden castle on this site to control not just the newly conquered English but also to protect the border. It was from here that soldiers would depart on their raids into Wales. Warfare came to Shrewsbury too. Those bullet holes in the gates (inset) date from an attack in the Civil War.

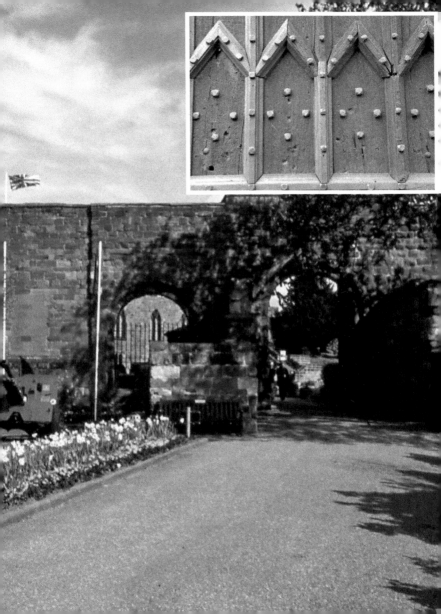

3. SHREWSBURY CASTLE

After the conquest of Wales and its unification with England, the castle fell into disuse until, in the 1500s, it became a private house. Briefly refortified during the Civil War, it was then totally remodelled in the late 1700s and has, once again, undergone remodelling to become the museum it now is: the Shropshire Regimental Museum.

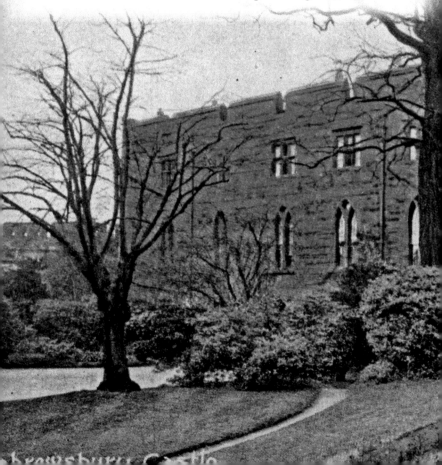

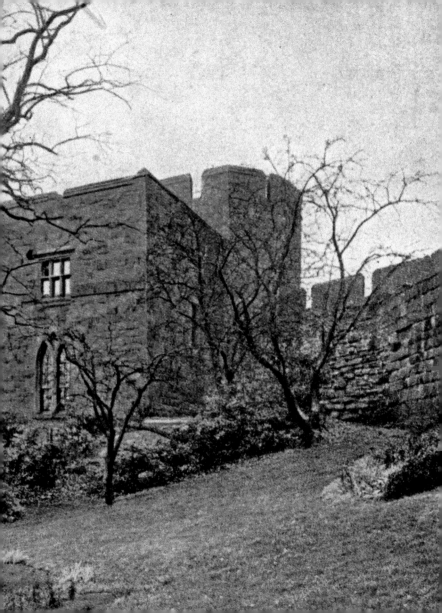

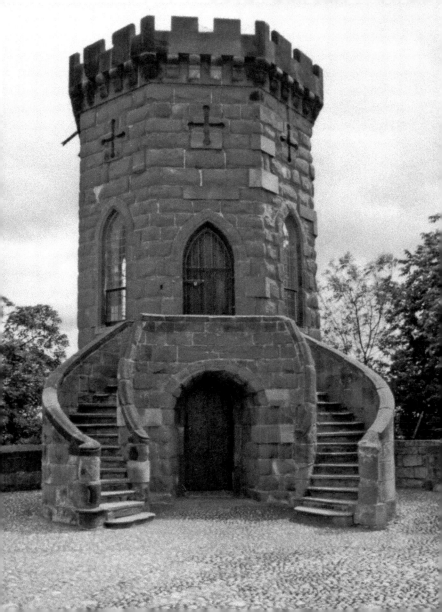

4. LAURA'S TOWER

You cannot move in Shropshire without tripping over examples of work by the famous engineer Thomas Telford. This pretty gazebo has to be the most romantic of all his works. It was built on the orders of Sir William Pulteney, then the owner of Shrewsbury Castle, as a coming-of-age gift for his daughter, Laura. One can easily imagine that young woman coming here to escape the hustle of the castle and write her letters, do her embroidery or just gossip and exchange secrets with her friends.

5. VIEW TO RAILWAY SIGNAL BOX

The signal box down by the tracks here was built in 1904 to serve both the London & North Western and the Great Western Railway companies. These days nearly all railway line junctions are computer controlled from centres, often based miles from the routes they control. This junction box, however, is still manned by humans and is, in fact, the largest mechanical signal box still in operation in all of Europe.

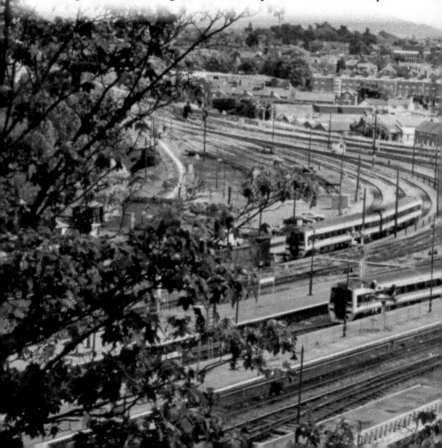

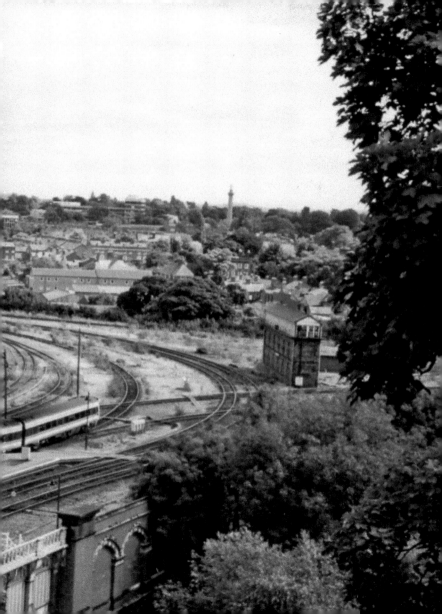

6. CASTLE GATES HOUSE

In medieval, and later, times it was quite common for timber-framed buildings to be dismantled and moved from one site to another. This house is just such an example, having previously stood in Dogpole. It was erected here at the end of the 1600s and was then covered entirely with plaster, which was removed in 1912.

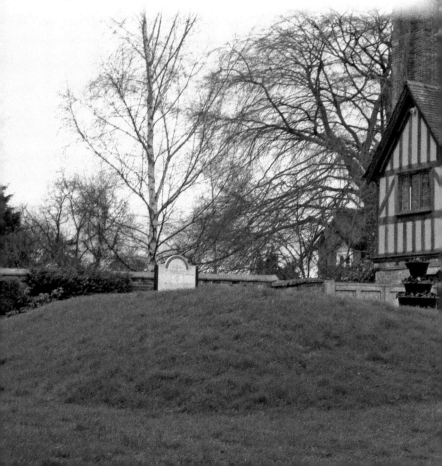

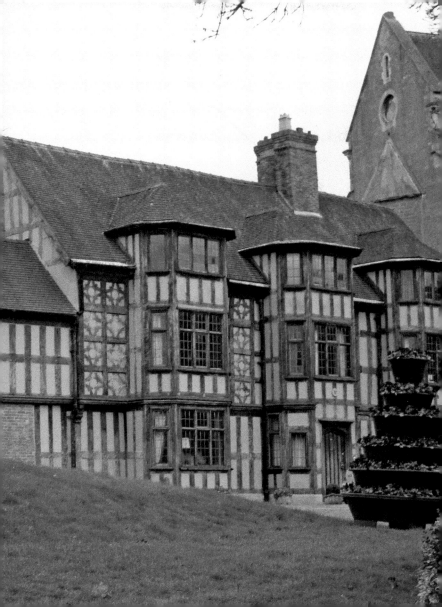

7. SHREWSBURY LIBRARY

This building was originally Shrewsbury School, which was founded in 1552. Notice the two schoolboys standing above and either side of the entrance; they are dressed in the school uniform of the early 1600s. Between them is a Greek inscription, which roughly translates as 'He who loves learning becomes learned', an excellent inscription for a building that was once a school and now serves as the town's library.

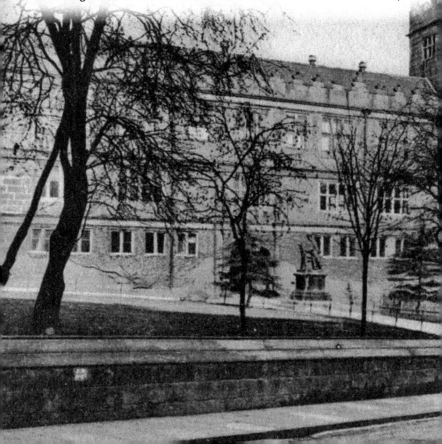

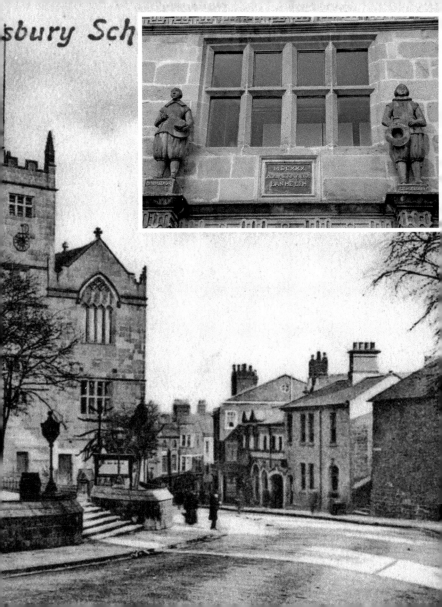

sbury Sch

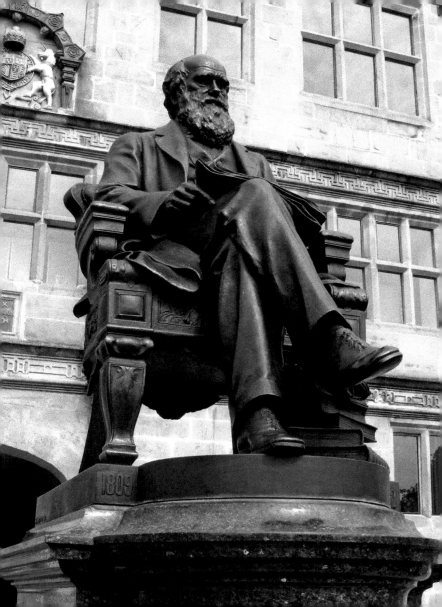

8. CHARLES DARWIN

Undoubtedly Shropshire's most famous son, Charles Darwin was born in Shrewsbury in 1809 and was educated here at Shrewsbury School. As a boy he was not considered academically bright. His headmaster, Samuel Butler, whose initials can be seen on nearby buildings, despaired and is said to have once told the boy that he was *pococurante*, meaning he was 'an unconcerned person' – in other words it was a polite way of saying he was ignorant! No one anticipated Darwin would grow up to become one of the finest scientists of his times.

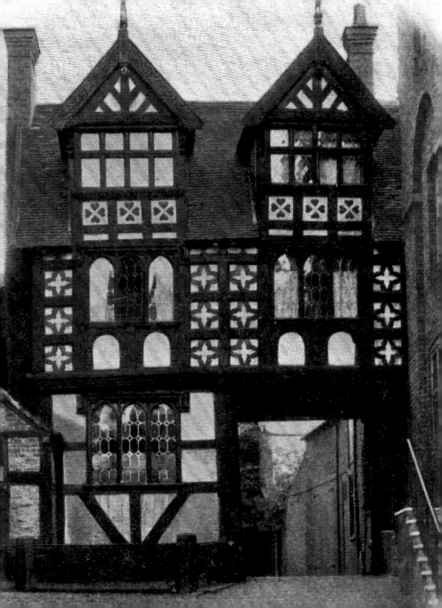

9. COUNCIL HOUSE ENTRANCE

This delightful little gatehouse serves as the entrance to what was formerly the Council House, where the president of the Council in the Marches (who was based in Ludlow) would stay when in town. It dates from the 1620s and is covered in the most delightful carvings. Notice the carvings above the gables – the one on the left is in the form of a medieval type of key. The picture below shows the rear of the gatehouse.

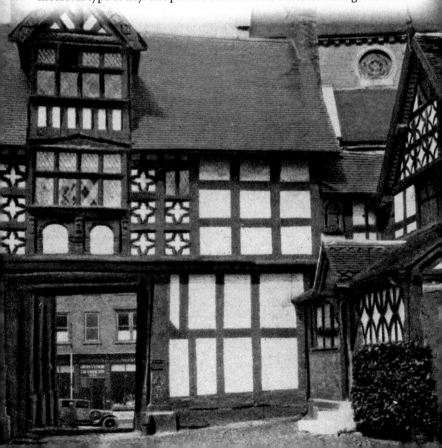

10. TRAITOR'S GATE/ST MARY WATERLANE

Officially known as St Mary's Waterlane, many refer to it as Traitor's Gate. This came about because when the town was attacked during the Civil War, local tradition has it that it was a traitor in the town who let the attackers in via this lane. As an access for water from the river, it strikes me as even riskier. Would you want to collect water from here, downstream of all the town's effluent?

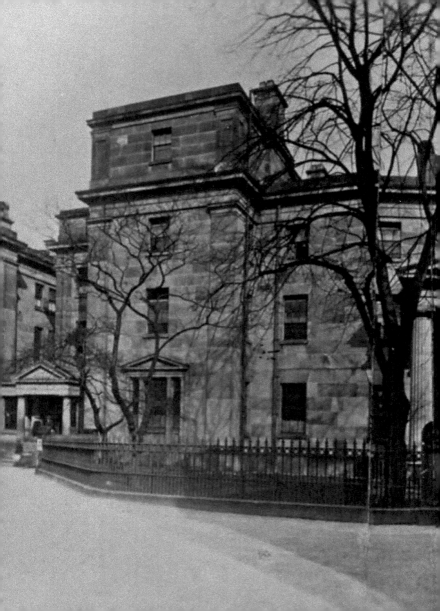

11. THE PARADE

Formerly the Royal Salop Infirmary, when built in 1830 it was one of the first hospitals in the country to have a hot water central heating system. The designation 'Royal' was conferred in 1914 during a visit by George V and Queen Mary, a month before the outbreak of war. In 1977 a new hospital was opened on the outskirts of town and The Parade, as it is now known, was converted into apartments and shops.

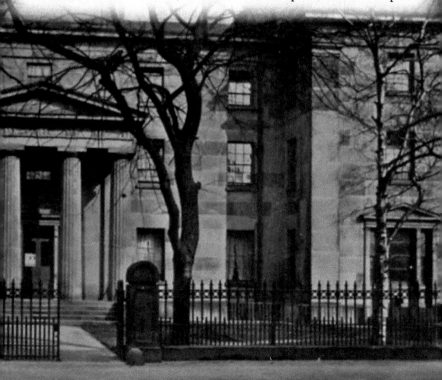

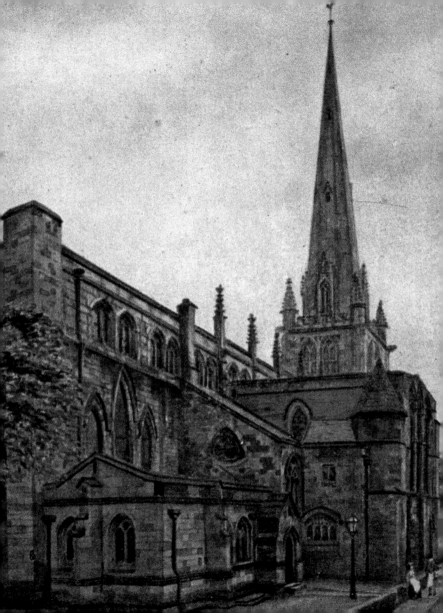

12. ST MARY'S CHURCH

At the time of the Norman Conquest there were already four churches in Shrewsbury. This was one of them and the foundations of that early Saxon church are still underneath the building, which has been extended, bit by bit, over the centuries. The spire, when first built, was then the third tallest in the country. Today, the church is redundant and is cared for by the Churches Conservation Trust.

13. ST MARY'S CHURCH – THE FALLEN ROOF

The top of the tall spire collapsed in 1894 and brought the ceiling of the church down with it. The accident happened at a time when the local people were raising money to erect the statue to Charles Darwin that we have already seen. Disapproving of Darwin and his theories of evolution, the vicar condemned the townspeople, saying the damage to St Mary's was a judgement on them for daring to raise the money.

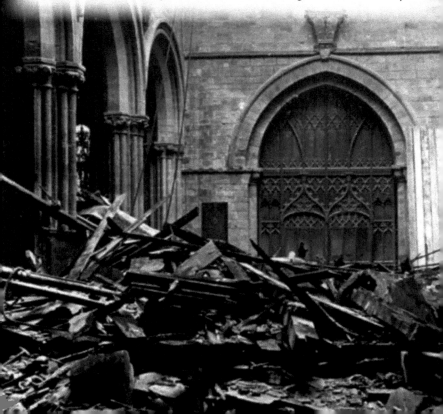

14. ST MARY'S CHURCH – THE STAINED GLASS

One of the glories of St Mary's Church is its stained glass. The collection includes glass from Germany, Belgium and Holland, although the window depicted below is English and dates from around 1350. Known as a Jesse window, it is, in effect, a teaching aid, showing the family tree of Jesse (lying at the base), his son David holding his harp and, when you visit the church, you will see Jesus depicted at the top.

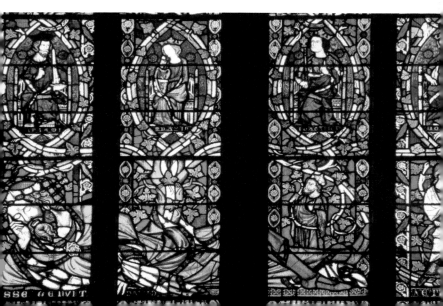

15. THE DRAPERS HALL

In medieval times it was impossible to trade in any commodity unless you were a member of the relevant trade union, or guild as they were then known. The most powerful guild in Shrewsbury was the Drapers Guild, who controlled the vital woollen cloth trade. This building, which dates from the 1500s, was the guild's headquarters. Interestingly, the Shrewsbury Drapers Guild survives to this day and its meetings are still held here.

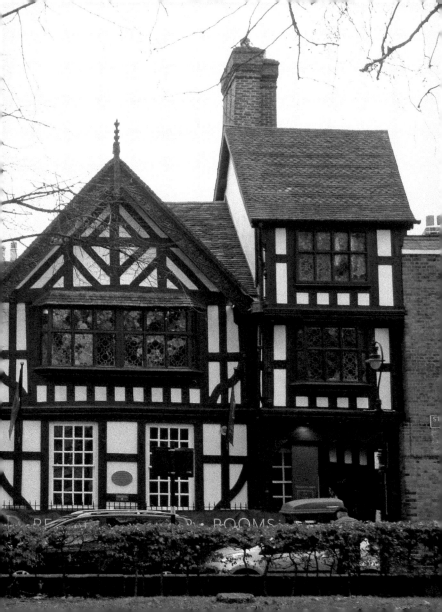

16. PRIDE HILL

The street's name recalls a family who traded here in medieval times. In those days there would have been a market cross at the top of the street; today a modern cross sits there, erected in 1952 to commemorate the 400th anniversary of Shrewsbury School. However, the site has rather more gruesome associations for it was here that the last Welsh Prince of Wales, Prince Dafydd, was executed in 1283.

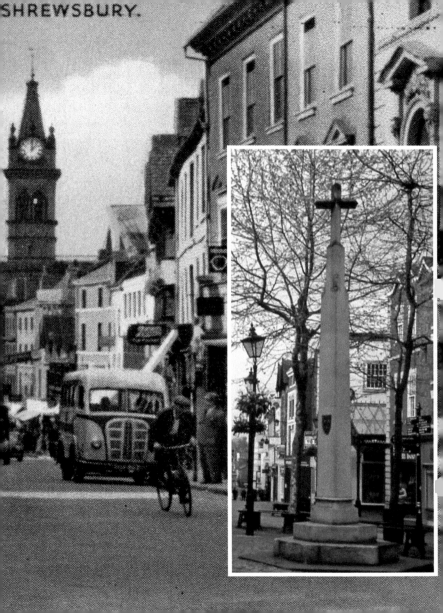

SHREWSBURY.

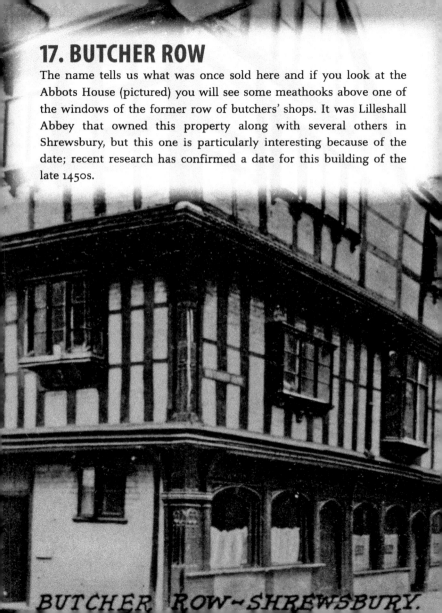

17. BUTCHER ROW

The name tells us what was once sold here and if you look at the Abbots House (pictured) you will see some meathooks above one of the windows of the former row of butchers' shops. It was Lilleshall Abbey that owned this property along with several others in Shrewsbury, but this one is particularly interesting because of the date; recent research has confirmed a date for this building of the late 1450s.

BUTCHER ROW ~ SHREWSBURY.

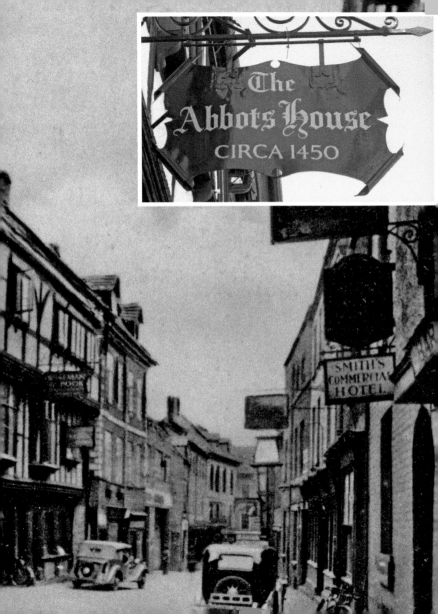

18. ST ALKMUND'S CHURCH

When St Alkmund's Church was rebuilt at the end of the 1700s all the windows in the new church were iron framed. The Victorians didn't like them and changed all but three. These three windows have recently been restored and, with their elegant styling, to my mind are the best feature of the church. St Alkmund was a Northumbrian saint who could be said to have visited the town briefly – but only after he was dead!

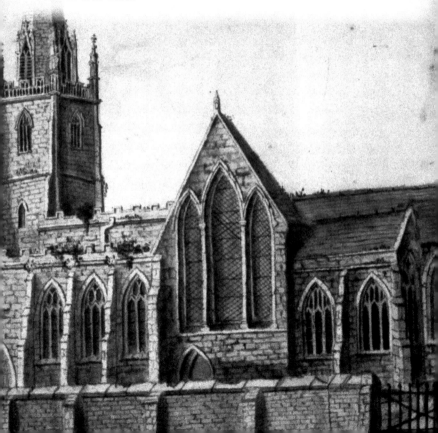

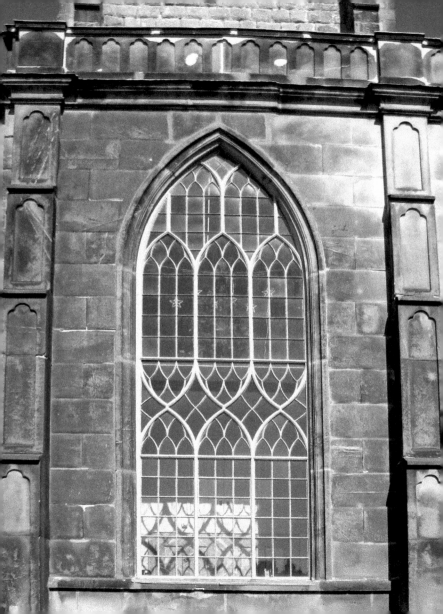

19. NEWPORT HOUSE

This house replaced Castle Gates House, which now sits near the castle. Built in 1696, its design already features much of the styling that we associate with later Georgian architecture. Notice, particularly, the fake windows on the right. It was the home of the Earl of Bradford, whose coronet can be seen above the door and, some 100 years later, was partially obscured by the porch with its iron (yes iron) columns.

20. WYLE COP

If you wished to trade in Shrewsbury in the past you would have needed to speak Welsh as well as English. The name 'Wyle Cop' reminds us of this; it means the way (old Welsh 'wyle') up to the top (Old English 'cop'). One side of the entire length of the street was pushed back in the 1920s to allow for two-way traffic. Fortunately the façades of the buildings were restored rather than changed.

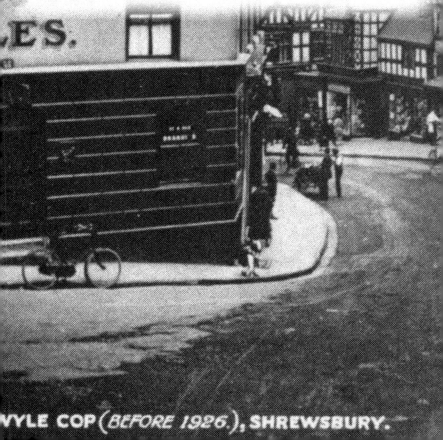

WYLE COP (*BEFORE 1926.*), SHREWSBURY.

21. HENRY TUDOR HOUSE

Henry Tudor House is named after Henry Tudor, who stayed here in 1485 when travelling from Wales on his way to meet with Richard III in Leicestershire at Bosworth Field. The building actually dates from the 1430s and was then a woollen cloth merchant's house; there are indications in one part of the building that there were even looms for weaving the cloth here at one time.

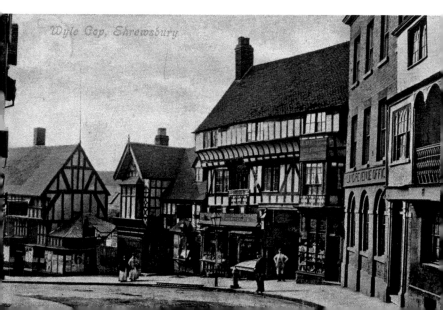

22. LION HOTEL

The Lion Hotel was an eighteenth-century coaching inn running coaches linking Shrewsbury with London, among others. The hotel also served as a social centre where the local elite could meet in its elegant Robert Adam-style assembly room. One visitor was Charles Dickens, who said, 'I lodged in the quaintest of little rooms, the ceiling of which I can touch easily.'

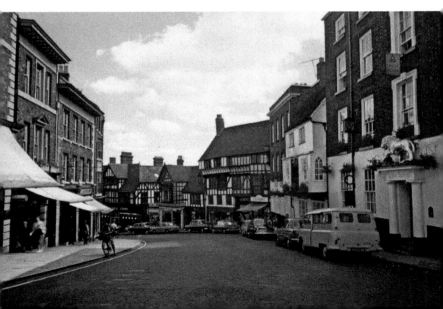

23. ST JULIAN'S CHURCH

St Julian's was another of the four Saxon churches already established in Shrewsbury at the time of the Norman Conquest. The earliest surviving part of the church is the base of the tower, which dates back to the 1100s. In the 1700s the nave was totally redesigned by Thomas Farnolls Pritchard, best known as the designer of the Iron Bridge.

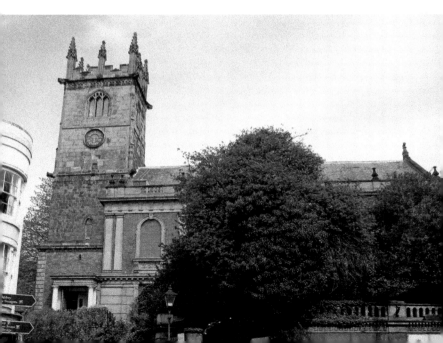

24. BEAR STEPS

Take the steps up into St Alkmund's churchyard and look around. The delightful building on your left is known as Bear Steps and was due for demolition in the 1960s. Fortunately, before too much had gone that decision was changed and it was totally restored. Where possible original timbers have been used; the section on the right is totally new but built in the old style. It's well worth visiting the art gallery inside.

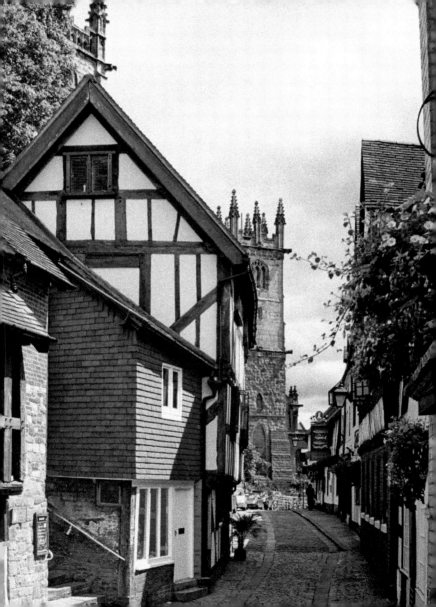

25. FISH STREET

It's fascinating to try and understand how buildings change over the years but without being able to study early photographs like this we would be so much worse off. Notice how that little house, just beyond the stairs, has lost an entire floor. A version of Charles Dickens's *A Christmas Carol* was filmed in Shrewsbury in the 1980s and this building served as Bob Cratchett's and Tiny Tim's home.

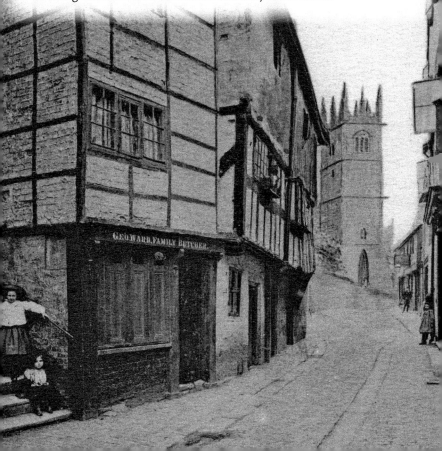

26. GROPE LANE

If you laugh when you see this sign, you've probably guessed the true explanation of its name – our ancestors were very honest when they named their streets! This narrow lane is one of Shrewsbury's famous shuts. There were once some 200 such narrow alleyways in the town but only a few survive. Before you emerge into the street beyond, look out for the carpenter's marks on the timbers on the left.

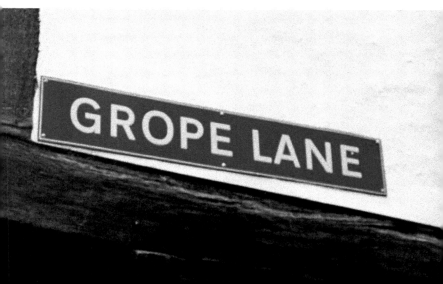

27. MARGARET THATCHER AND MICHAEL HESELTINE

Cross the road and look back. Like Bear Steps this building, too, has been restored but what I love is the way the restorers have given old traditions a new focus. Look above the large window upstairs. Those two heads depict Margaret Thatcher and Michael Heseltine (who has a Shrewsbury connection since he attended Shrewsbury School). The date? 22 November 1990, the day Margaret Thatcher resigned as prime minister.

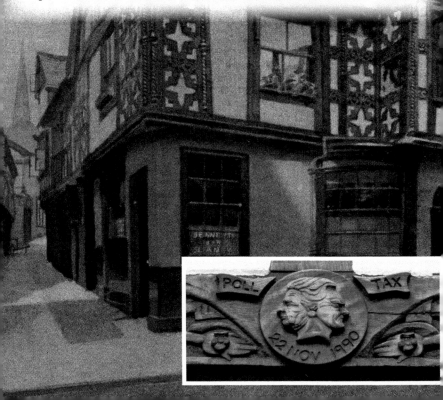

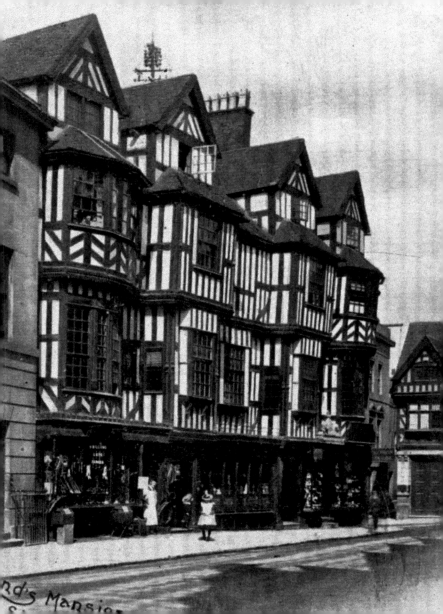

rd's Mansio

28. IRELAND'S MANSION

When I first visited Shrewsbury I was astounded by Ireland's Mansion. It's so large. It's also in the heart of the town and dates from the late 1500s, and yet it has survived. When you see buildings of this status in Shrewsbury they were invariably the homes of wealthy merchants and Ireland's Mansion is no exception. When he built this house Robert Ireland obviously wanted to show off his wealth – all that timber wouldn't have come cheap!

29. LLOYDS BANK

Lloyds Bank, however, is new. The former timber building was relatively recent – only Victorian! The bank was built in the 1960s and won an award for the way it fits in with the other buildings around. You laugh, but notice how each floor sticks out beyond the floor below, and notice also the vertical lines of concrete and glass. It's a modern building mimicking the old timber ones nearby.

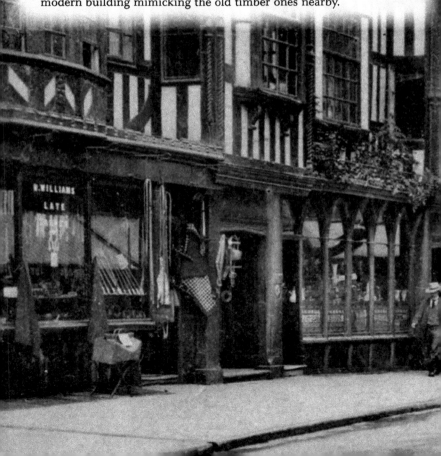

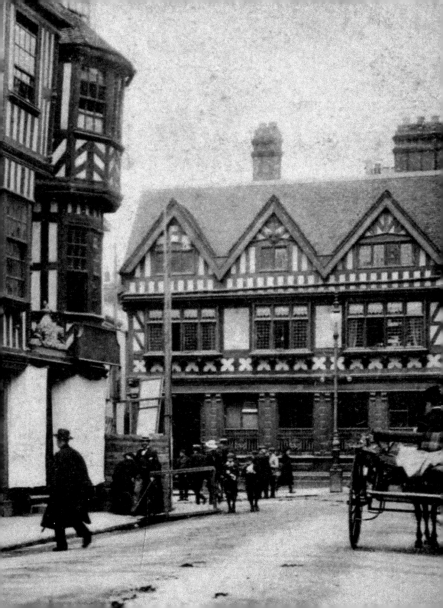

30. THE SQUARE

Despite the passing years this view has changed little, even if the vehicles are now rather different. The Square is very much the heart of the town and there's seldom a weekend when there is nothing taking place here. You name it: farmers' markets or German markets, Morris dancers or buskers, and even (at Christmas) community carol singing.

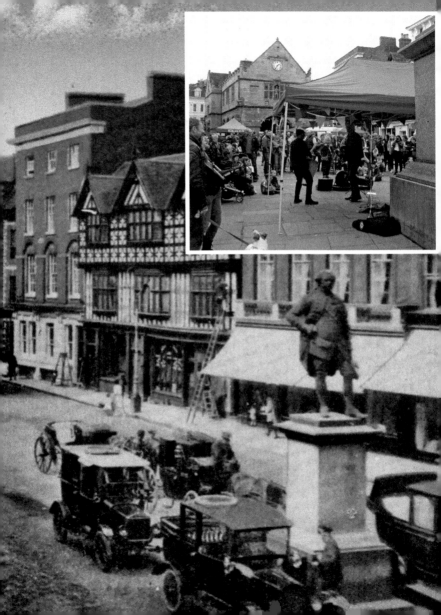

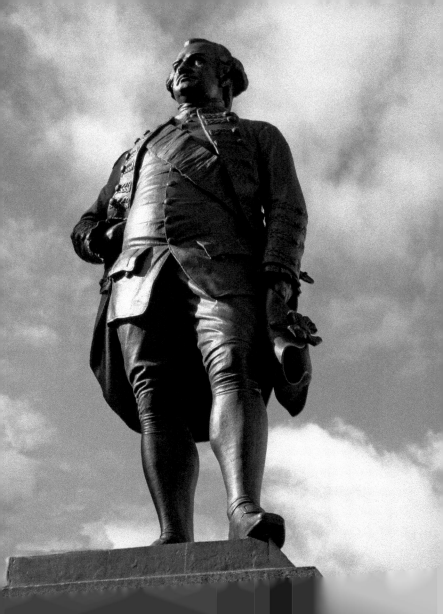

31. ROBERT CLIVE

Robert Clive, Clive of India, was born in 1725 in the village of Moreton Say near Market Drayton. A bit of a tearaway as a boy, his father got him a job as a clerk with the East India Company – he was shipped off to India and, hopefully, out of trouble. He joined the company's army and turned out to be an excellent leader and tactician, so much so that, at the age of only thirty-one, he won the Battle of Plassey, thereby ensuring that India became part of the growing British Empire. His statue reminds us that he served as mayor of the town in 1762–63.

32. THE OLD MARKET HALL

This market hall was built in 1596 with a covered market at ground-floor level. It was on the upper floor that the drapers, or cloth merchants, had their market. Notice, also, the coat of arms on the far side of the building with its English lion and Welsh dragon, reminding us that the Tudor monarchs had Welsh ancestry. Today the building houses a café and cinema.

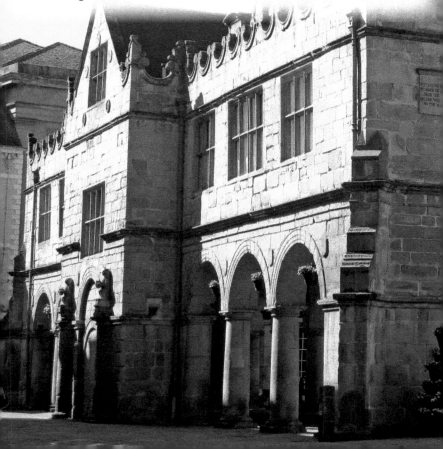

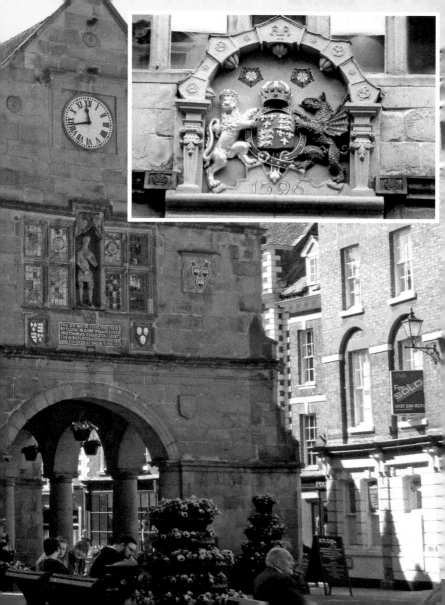

1596

THE XV DAY OF IUNE WAS THIS
BUYLDING BEGUN WILLIAM IONES
AND THOMAS CHARLTON GENT
THEN BAYLIFFES AND WAS ERECTED
AND COVERED IN THEIR TIME

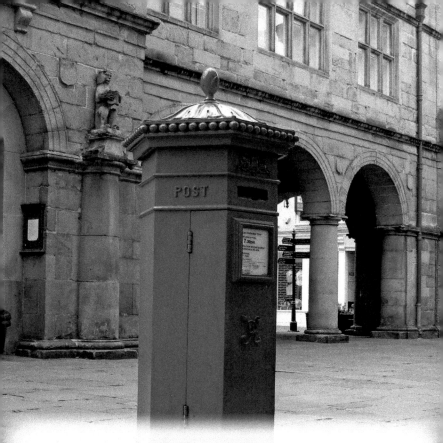

33. GULLET PASSAGE

There was once a pond in the Square (complete with ducking stool in medieval times). A pond in the heart of a market would have been a receptacle for all kinds of rubbish, and when it rained and the pond flooded, that filthy water needed to escape. All of which explains the name of this narrow and winding shut. The letterbox that stands by the entrance to Gullet Passage is a lovely Victorian survival.

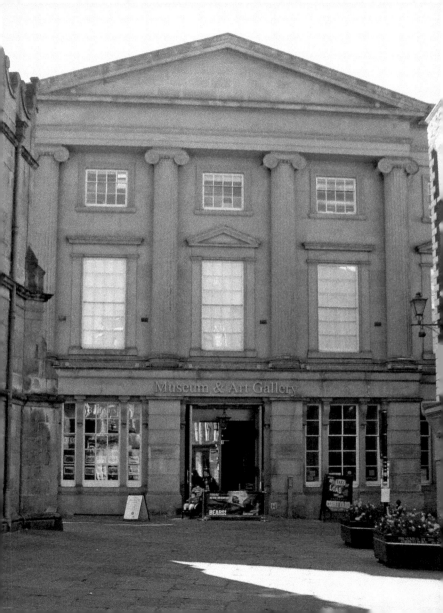

Museum & Art Gallery

34. SHREWSBURY MUSEUM AND ART GALLERY

Shrewsbury's Museum and Art Gallery only opened in 2014. The building, however, was formerly known as the Music Hall, which opened in 1840. I was once told that 'it never made a profit but some things are more important than money', and certainly its recent conversion into a museum has given visitors the chance to properly explore a fascinating building. The photograph below shows the main auditorium set out ready for the performance of a concert.

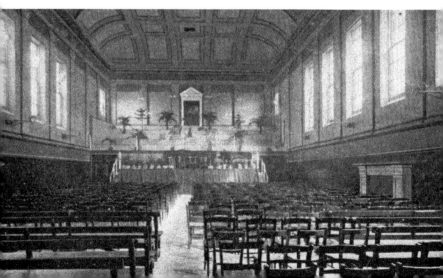

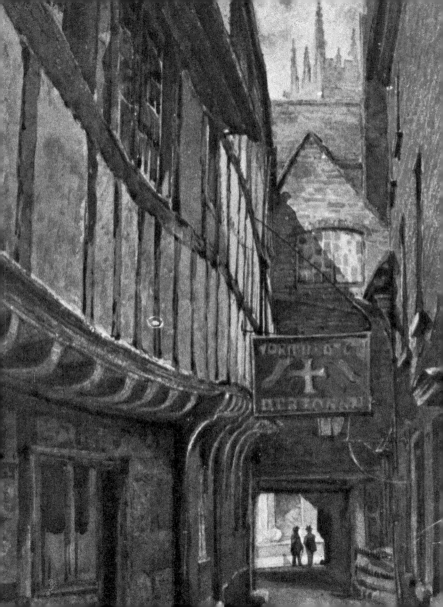

35. THE GOLDEN CROSS

It may not be the oldest building in the town but The Golden Cross is the oldest pub. The building dates from the mid-1400s and its name reminds us that it was once closely linked to Old St Chad's Church across the street. The pub would have provided accommodation for people visiting the church but, most importantly, it also served as the church's sacristy, where church vestments and plate were kept secure.

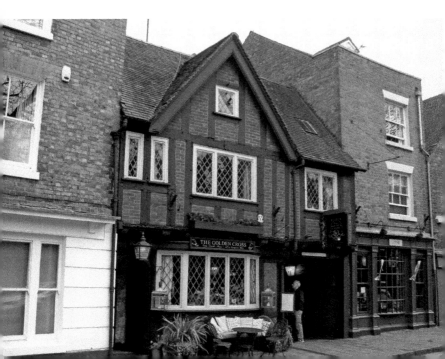

36. OLD ST CHAD'S CHURCH

Although founded in Saxon times, Old St Chad's Church was rebuilt by the Normans. Unfortunately, when the Normans added on new sections to their early churches they seldom worried about the effect this would have on the original, shallow, foundations. So, it is hardly surprising that one night in 1788 the tall tower that had been put on top of the earlier church collapsed, bringing much of the rest of the church down with it.

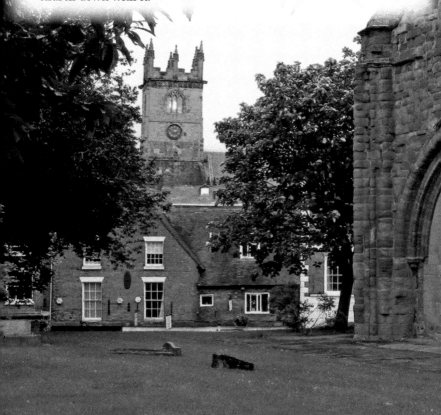

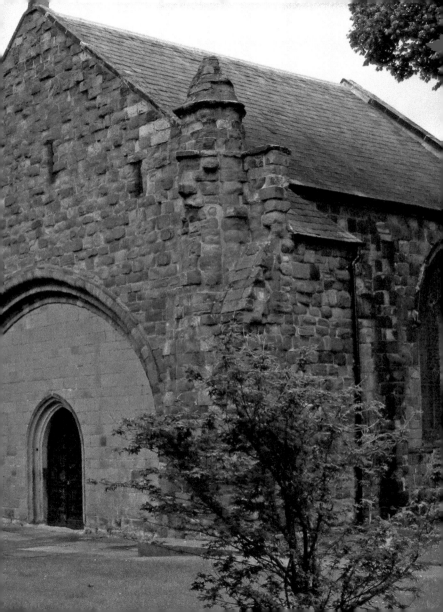

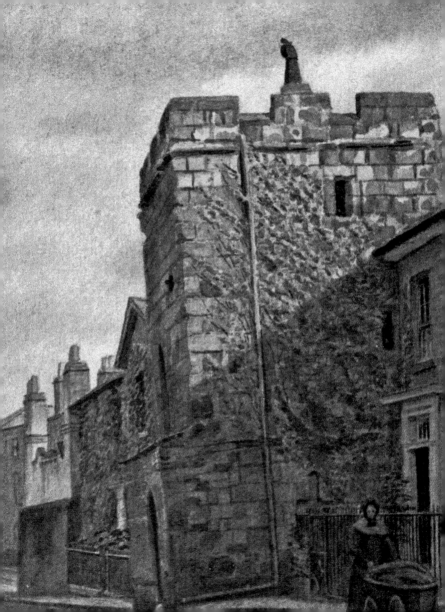

37. TOWN WALLS TOWER

Although we can assume that early Shrewsbury had defences, it wasn't until the 1200s that proper stone walls were built. Glimpses of those walls can be seen in various parts of the town, but the best section is along the appropriately named Town Walls Road. The tower pictured here is the only surviving medieval tower on those walls. Now cared for by the National Trust, it is occasionally open to the public.

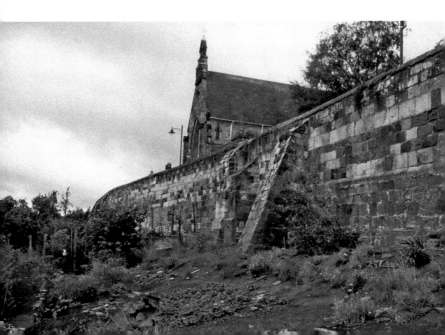

38. KINGSLAND MANSION

This rather fancifully designed building was the Eye, Ear and Throat Hospital, which opened in 1881. It cost around £12,000, the money being raised by public subscription. The shiny red terracotta-like bricks used in the construction are known as Ruabon bricks, after the town in Wales where they were produced; in fact, so many of these bricks were produced that Ruabon was nicknamed Terracottapolis. The hospital closed in 1998 and has been converted into apartments.

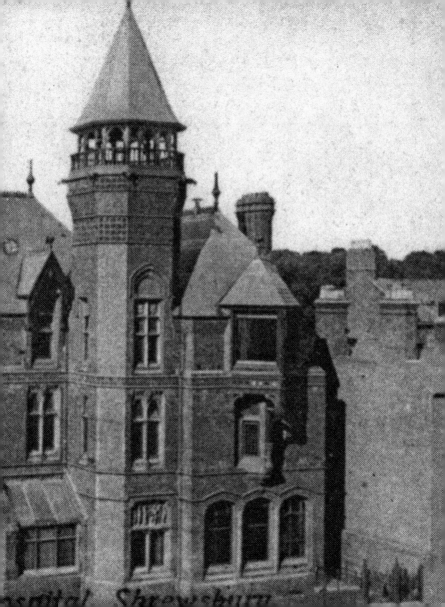

ospital, Shrewsbury

39. NEW ST CHAD'S CHURCH

Consecrated in 1792, New St Chad's Church was designed by local architect George Steuart. That round nave was far too modern in style for many people at the time and, indeed, local tradition has it that Steuart went against the wishes of the parish council when he built it instead of their favoured cruciform design. The plaque on the floor outside the entrance (inset) reminds us that it was here that Charles Darwin was baptised.

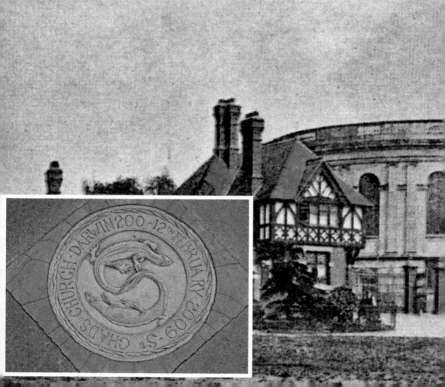

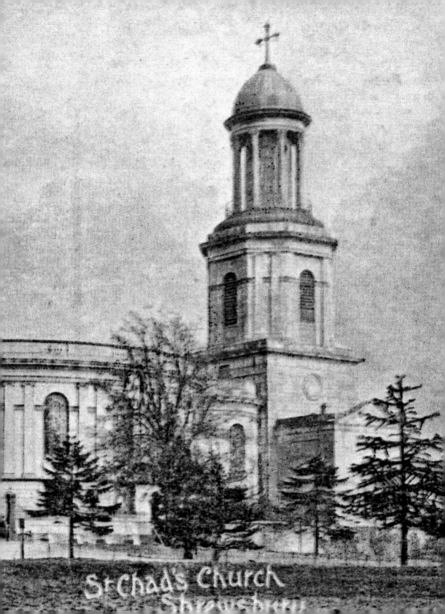

St Chad's Church
Shrewsbury

40. SCROOGE'S GRAVE

Earlier we saw the house used in the 1980s film version of *A Christmas Carol* as the home of Tiny Tim. Now, in the churchyard behind St Chad's we find Ebenezer Scrooge's grave – if you look carefully you'll see that it's an old gravestone, the original carving on it being almost entirely obliterated. When the film crew left town the stone remained, becoming a tourist attraction in its own right.

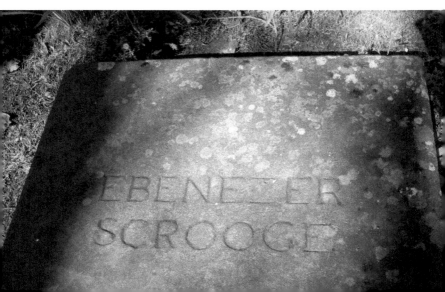

41. THE WAR MEMORIAL

This photograph shows the occasion in 1922 when the memorial to those from Shropshire who died in the First World War was consecrated. Once again money to erect the memorial was raised by public subscription. Indeed, so much money was raised that there was enough left over to build an extension to the main hospital that added twenty-two beds for children and eight maternity beds.

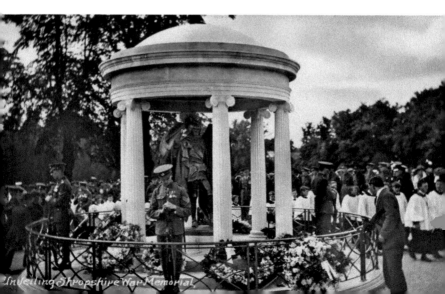

Unveiling Shropshire War Memorial.

42. THE QUARRY

Quarry Park extends for some 29 acres and was created in 1719, making it one of the first municipal gardens open to the public anywhere in the country. From medieval times this area was used for annual festivals and this continues today with the Shrewsbury Flower Festival, which (according to the *Guinness Book of Records*) is the 'longest-running flower show in the world'. The bandstand was built in 1879.

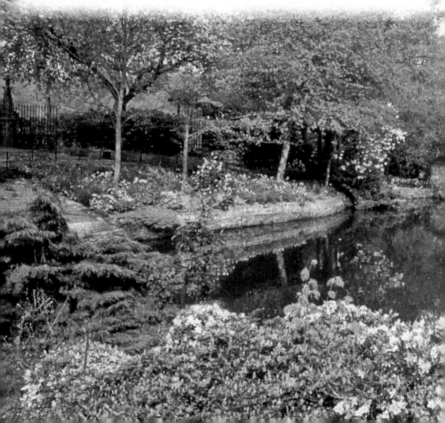

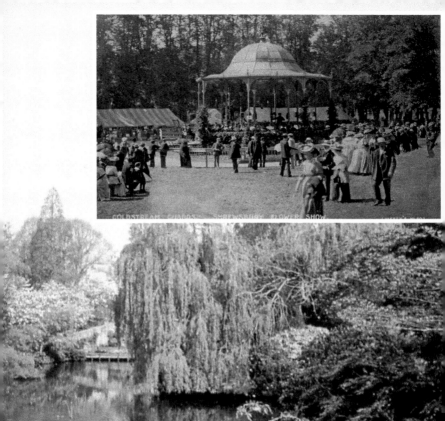

COLDSTREAM GUARDS · · SHREWSBURY FLOWER SHOW

43. PERCY THROWER AND THE DINGLE

In the heart of the Quarry Park is the former quarry that gives it its name. Now with a large pond and laid-out gardens, it always looks attractive, no matter the time of year. Among the flower beds you may come across the bust of someone who looks rather familiar: Percy Thrower. Britain's first 'television gardener' was park superintendent here for many years.

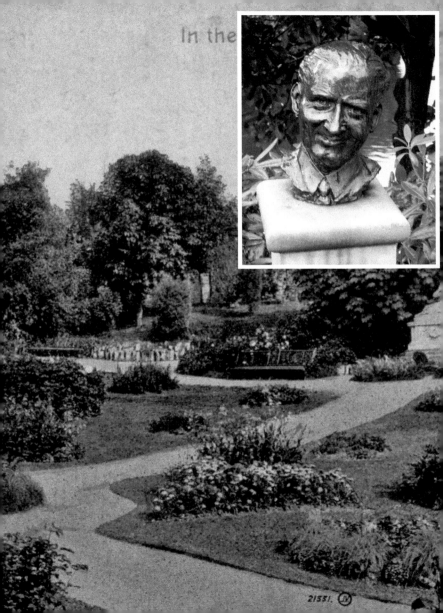

In the

44. THE RIVER SEVERN

The River Severn is the longest river in Great Britain and almost completely circles Shrewsbury. After serving a purpose in defending the early town and then as a conduit for trade, by the 1800s it was being used for leisure pursuits – the buildings just across the river are for Shrewsbury School's rowing club. Notice, too, the post in the foreground for the rope ferry that used to cross the river at this point.

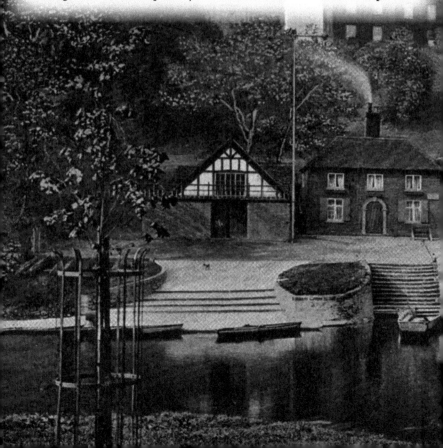

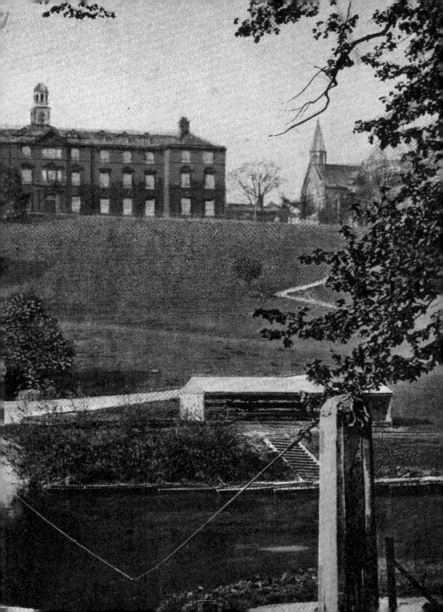

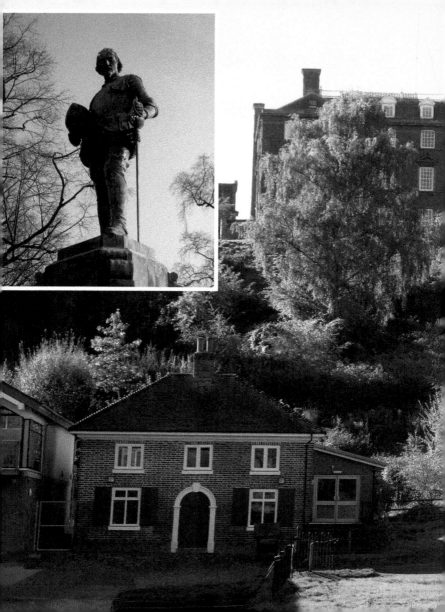

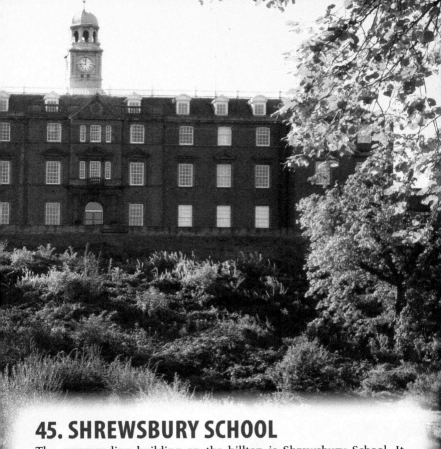

45. SHREWSBURY SCHOOL

The commanding building on the hilltop is Shrewsbury School. It
was originally built in 1760 as a foundling hospital for 400 orphans.
Later it became the town's workhouse before being taken over by
Shrewsbury School in 1882. The school has many famous old boys
and one of these is the Elizabethan courtier, poet and soldier Philip
Sidney. The Sidney statue in the school's forecourt (inset) serves as its
war memorial.

46. THE RIVERSIDE WALK

Lined with trees, the walks in the Quarry Park are always glorious. Originally planted out in the early 1700s, by the mid-1900s, when Percy Thrower arrived, the trees were becoming dangerous. Thrower promptly upset many people in the town by cutting them down, but look around you and you'll see that he had the avenues replanted and, once again, it's a pleasure to walk here.

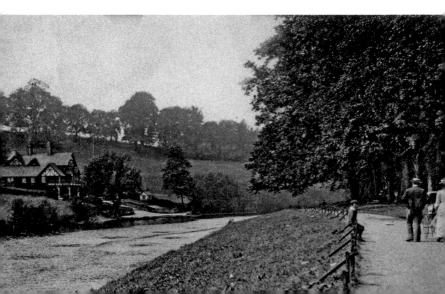

47. KINGSLAND BRIDGE

Kingsland Bridge was built in 1883 and, because of its height above the river, can still be used when the Severn is in full flood. That height also featured in the First World War when *The Shrewsbury Chronicle* described how two daredevil pilots gave an air display over the quarry that culminated in one of them flying his plane underneath the Kingsland Bridge eight times. Precision flying, especially in 1917.

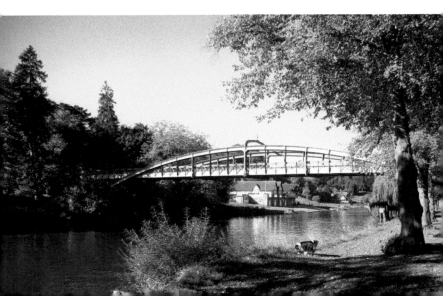

48. ENGLISH BRIDGE

When it was built in 1774 the English Bridge had a much sharper arch. The advent of modern traffic meant that in the 1920s the bridge needed to be widened and the arch was then lowered. Fortunately the borough surveyor at the time, Arthur Ward, insisted that the design of the bridge should be maintained and original stone facings reused. The bridge was then reopened by Queen Mary in 1927.

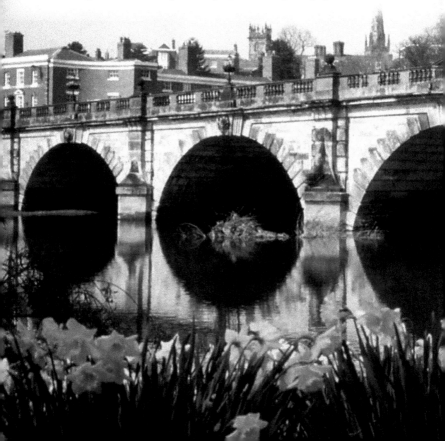

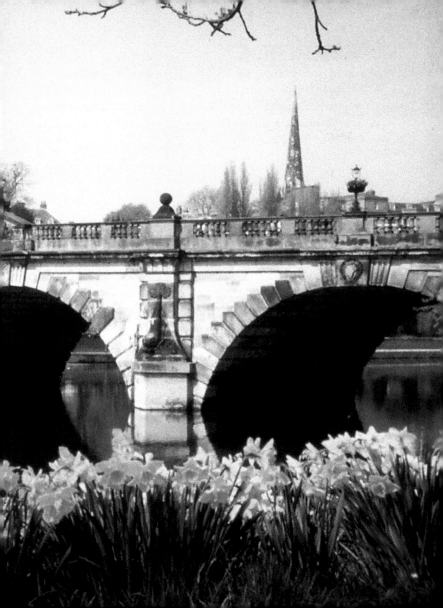

49. WYLE COP

I love this view of Wyle Cop with the cattle being herded casually down the street. The photograph dates from the early 1900s, before both the street and the English Bridge were widened. Looking in the other direction you get a clearer impression of just how steep the original angle of the bridge once was.

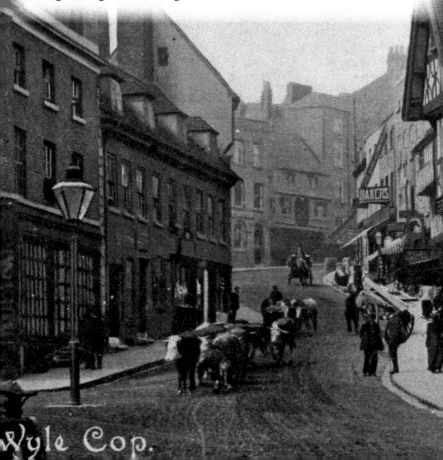

Wyle Cop.

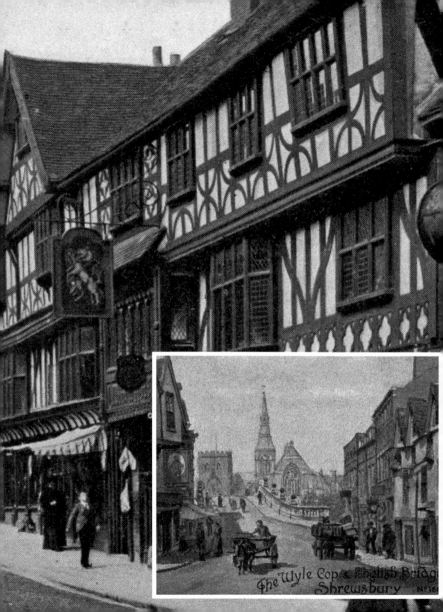

The Wyle Cop & English Bridge
Shrewsbury

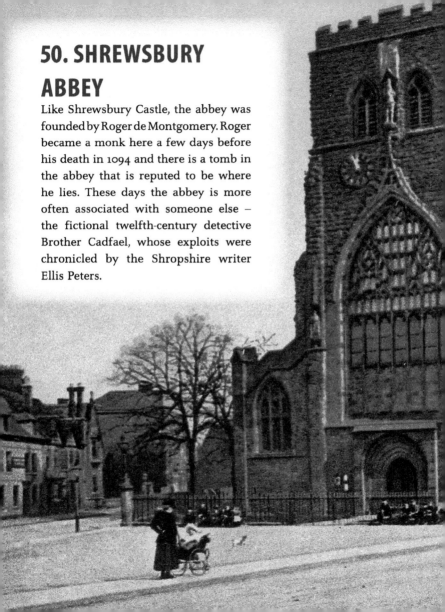

50. SHREWSBURY ABBEY

Like Shrewsbury Castle, the abbey was founded by Roger de Montgomery. Roger became a monk here a few days before his death in 1094 and there is a tomb in the abbey that is reputed to be where he lies. These days the abbey is more often associated with someone else – the fictional twelfth-century detective Brother Cadfael, whose exploits were chronicled by the Shropshire writer Ellis Peters.

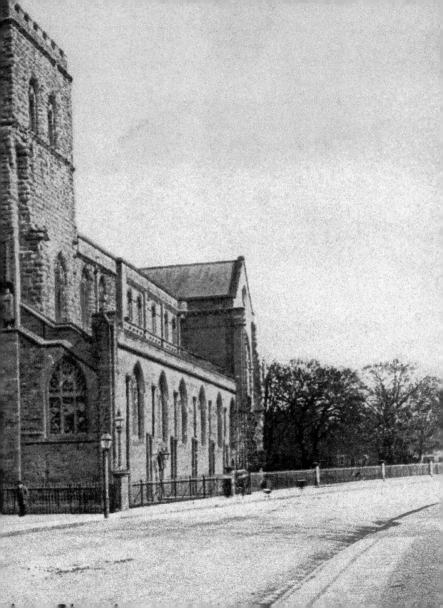

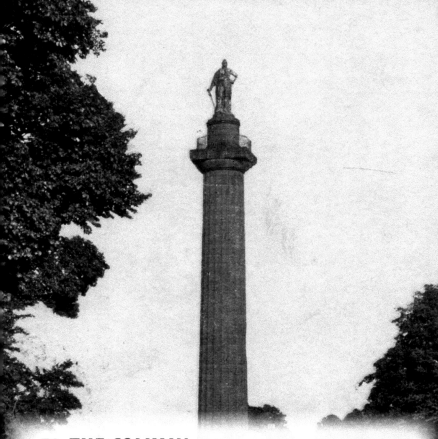

51. THE COLUMN

At 40.7 metres tall, this is the tallest Doric column in the world. It commemorates General Lord Rowland Hill, who was born at Hawkstone Hall in the north of the county. The column was completed on 18 June 1816, exactly a year after the Battle of Waterloo, where Hill served (along with three of his brothers), although Hill really made his name in the earlier Peninsular Wars.